D1542532

THE

ART

OF

THE

AFFAIR

THE

Art

OF THE

Affair

An Illustrated History of Love, Sex, and Artistic Influence

**Catherine
Lacey**

**Forsyth
Harmon**

BLOOMSBURY

NEW YORK · LONDON · OXFORD · NEW DELHI · SYDNEY

Bloomsbury USA
An imprint of Bloomsbury Publishing Plc

1385 Broadway 50 Bedford Square
New York London
NY 10018 WC1B 3DP
USA UK

www.bloomsbury.com

BLOOMSBURY and the Diana logo are trademarks of Bloomsbury Publishing Plc

First published 2017

© Catherine Lacey and Forsyth Harmon, 2017

All rights reserved. No part of this publication may be reproduced or transmitted in any form or by any means, electronic or mechanical, including photocopying, recording, or any information storage or retrieval system, without prior permission in writing from the publishers.

No responsibility for loss caused to any individual or organization acting on or refraining from action as a result of the material in this publication can be accepted by Bloomsbury or the author.

ISBN: HB: 978-1-63286-655-4

Library of Congress Cataloging-in-Publication Data is available.

2 4 6 8 10 9 7 5 3 1

Designed by Andrew Shurtz
Printed in China by RRD Asia Printing Solutions Limited

To find out more about our authors and books visit www.bloomsbury.com. Here you will find extracts, author interviews, details of forthcoming events and the option to sign up for our newsletters.

Bloomsbury books may be purchased for business or promotional use. For information on bulk purchases please contact Macmillan Corporate and Premium Sales Department at specialmarkets@macmillan.com.

I shall never believe
in the classification of love among
the purely physical joys (supposing that
any such things exist) until I see a gourmet
sobbing with delight over his favorite dish
like a lover gasping on a young shoulder.
Of all our games, love's play is the only one
which threatens to unsettle the soul, and is also
the only one in which the player has to abandon
himself to the body's ecstasy. To put reason
aside is not indispensable for a drinker,
but the lover who leaves reason
in control does not follow
his god to the
end.

Marguerite Yourcenar
Memoirs of Hadrian

INTRODUCTION

The relationships in an artist's life — whether romantic, platonic, or collaborative — create an unseen scaffolding of their life's work. A painter's muse shapes her oeuvre. Friends inspire a novelist's heroes; enemies become villains. A single heartbreak spawns decades of poems. Creative people are drawn to one another, as notorious for falling in love as they are for driving one another insane. Seen a certain way, the history of art and literature is a history of all this love.

I started collecting these stories several years ago as a goal-oriented form of procrastination, though I was unsure of my actual goal. I kept a file titled AFFAIRS, filling it with photographs, letters, excerpts from biographies. Some I already knew (Igor Stravinsky and Coco Chanel, Arthur Miller and Marilyn Monroe) but there were plenty of surprises—that Madonna and Jean-Michel Basquiat were once disastrously entwined, that Frida Kahlo had an unrequited crush on Georgia O'Keeffe, that Simone de Beauvoir and Nelson Algren broke each other's hearts. And though all these stories were fascinating, it was only when they began to link up, connecting artists from disparate fields, that I saw how it was more than just gossip, but also a chain of influence. One artist's muse had an art and muse of her own, or was married to a composer who fell in love with a writer who was married to another writer, until those writers divorced, each marrying surrealist painters, then putting it all in a novel. This was far more than a history of love —it was a carnage of affairs, the inspiration behind countless works of art.

Like a conspiracy theorist, I started mapping out this web on a large whiteboard and spent afternoons adding new names. What began as a passing curiosity became a minor obsession. But it never would have become a book if I hadn't turned to a creative partner of my own, asking Forsyth Harmon to join me as an illustrator and curator.

Together, we decided to take a slightly broader definition of "affair"—not just relationships of sex and deceit, but collaborations, friendships, mentorships, and rivalries. There were many unlikely alliances. Sartre and Miles Davis were pals. Marilyn Monroe used her fame to get Ella Fitzgerald gigs. Richard Wright cited Gertrude Stein as a major influence. Albert Camus was in love with Truman Capote (or so Truman said). And I am still not over the fact that there is a single degree between Salvador Dalí and Black Sabbath.

Another joy of the research was discovering forgotten geniuses, those either overshadowed by their more famous friends or marginalized for their race, sex, or sexual identity. I fell in love with the work of three incredible painters—Romaine Brooks, Léonard Tsuguharu Foujita, and Beauford Delaney—saddened that this was the first I'd heard of them. Margery Latimer, a prolific young writer whose life was cut short giving birth to her and Jean Toomer's child, was another example. Lil Hardin Armstrong, an accomplished jazz pianist who had a huge influence on her husband Louis's career, was yet another. Many more are in these pages—and even more, sadly, are not.

For some artists in the book, their marginalization may have helped them find each other. Since we mostly limited ourselves to artists at work in the twentieth century, many here who were either of color, queer, or both were practically obliged to go to Paris—the only place, it seems, that would just let them be. James Baldwin, Josephine Baker, Alice B. Toklas, Gertrude Stein, Beauford Delaney, Langston Hughes, and Miles Davis are just a few examples. Though many had successful careers, the stories of the prejudice they faced are heartbreaking.

There's plenty of sadness—and scandal, as well. After Anaïs Nin broke the heart of a young Gore Vidal, he turned against her vengefully and publicly. Tallulah Bankhead's sexual exhibitionism nearly got Billie Holiday fired from her gig at the Strand. Orson Welles held a torch for Dolores del Río decades after their love had cooled. But between the broken hearts and jealousies were plenty of more successful pairings. Max Ernst and Dorothea Tanning had a long and loving marriage. Jean Cocteau and Jean Marais were in love until Cocteau's death. There were a few couples—electronic music pioneers Louis and Bebe Barron, for example—who dissolved their romantic relationships but continued as fruitful collaborators. And we end the book on Lou Reed and Laurie Anderson, who met later in their careers but seemed to have had the sort of relationship we should all aspire to.

What is so compelling about these connections, ultimately, is their unknow-ability. There were letters intentionally lost to protect others, or burned in an attempt to purge a heartbreak. And some couples tread in secrecy, leaving no evidence behind but rumor. But even when we think we know everything we can about two people—through their books, letters, paintings, photographs, and journals—we will never know what they really saw when they looked at each other. The real space between people is always private. These loves always vanish, leaving us with the work they inspired.

Catherine Lacey

[CHAPTER ONE]

When the Wicked Man

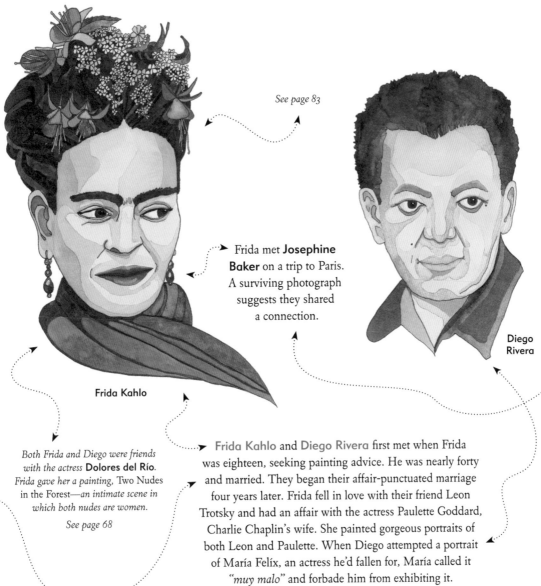

See page 83

Frida met **Josephine Baker** on a trip to Paris. A surviving photograph suggests they shared a connection.

Diego Rivera

Frida Kahlo

*Both Frida and Diego were friends with the actress **Dolores del Río**. Frida gave her a painting, Two Nudes in the Forest—an intimate scene in which both nudes are women.*

See page 68

Frida Kahlo and Diego Rivera first met when Frida was eighteen, seeking painting advice. He was nearly forty and married. They began their affair-punctuated marriage four years later. Frida fell in love with their friend Leon Trotsky and had an affair with the actress Paulette Goddard, Charlie Chaplin's wife. She painted gorgeous portraits of both Leon and Paulette. When Diego attempted a portrait of María Félix, an actress he'd fallen for, María called it *"muy malo"* and forbade him from exhibiting it.

5

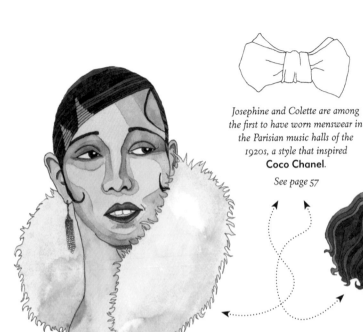

Josephine and Colette are among the first to have worn menswear in the Parisian music halls of the 1920s, a style that inspired **Coco Chanel**.

See page 57

Josephine Baker

Colette

Le Corbusier

Josephine Baker met **Le Corbusier** on a boat from South America to France. Her singing moved him to tears and an onboard romance ensued. Based on the architect's nude portraits of her, Josephine told him he should have been a painter instead.

During a summer vacation in Brittany, **Colette**, forty-seven and married to **Henry de Jouvenel**, began an affair with her sixteen-year-old stepson, **Bertrand de Jouvenel**, a writer himself. She had already published *Chéri*, a novel about an affair between an older woman and a young man. Colette later confessed all to Henry, who was having an affair of his own with a Romanian princess. The marriage did not survive.

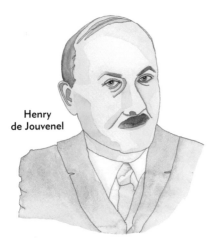

Henry
de Jouvenel

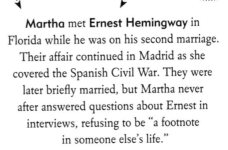

Martha
Gellhorn

Bertrand met and fell in love with
Martha Gellhorn, a young journalist, while
she was visiting Paris in 1930.
Bertrand introduced her to his stepmother,
an encounter Colette described as
"Absolute, utter hell."

Bertrand
de Jouvenel

Martha met **Ernest Hemingway** in
Florida while he was on his second marriage.
Their affair continued in Madrid as she
covered the Spanish Civil War. They were
later briefly married, but Martha never
after answered questions about Ernest in
interviews, refusing to be "a footnote
in someone else's life."

Jean Rhys

Ford
Madox
Ford

Robert Lowell wrote a
poem about his friend
Ford Madox Ford.
He called it
"Ford Madox Ford."

On Ezra Pound's recommendation,
Ford Madox Ford hired a young
Ernest Hemingway as an editor of
the *transatlantic review*, but Ernest
grew quickly jealous of Ford's career
and the beautiful, talented women who
surrounded him. "The thing to do with
Ford is kill him," Ernest complained to
Ezra. "This ain't personal. It's literary."
Ford, for his part, continued his
vocal support of Ernest and
his polarizing work.

Jean Rhys and **Ford** met in Paris.
Ford had the brilliant idea to
invite her to live with him and his
partner, Stella Bowen. He and Jean
soon had an affair. In her partially
autobiographical novel, **Quartet**,
Jean named a character
Heidler, a reference to Ford's
given last name, Hueffer. Ford
countered with his own book,
When the Wicked Man.

Ernest
Hemingway

*Elizabeth was lifelong friends with the writer **Mary McCarthy**.*

Elizabeth Hardwick, a formidable critic and author of several acclaimed books, met poet Robert Lowell at the end of his marriage to the Pulitzer Prize–winning writer Jean Stafford. After cementing their relationship at the Yaddo writers' colony, the two married.

*While still a grad student at Columbia, Elizabeth saw **Billie Holiday** perform in Manhattan jazz clubs. She later profiled Billie in the* New York Review of Books.

See page 69

Elizabeth Hardwick

Robert Lowell

Robert embarked on a cycle of infidelity and repentance until he met British writer **Caroline Blackwood**, also at the end of her second marriage, in 1970. Almost immediately, he moved to London to be with her and began publishing poems that wove in excerpts from pleading letters Elizabeth sent from New York. These were collected in a book called ***The Dolphin***, the nickname Robert had for his new wife.

On a solo trip to New York, in the cab en route to Elizabeth's apartment, Robert had a heart attack and died. It's said he was clutching a **Lucian Freud** portrait of Caroline.

Caroline
Blackwood

At a chance meeting with a
teenage Caroline, **Pablo Picasso**
drew on her hands. She refused to
wash them for some time.

See page 39

Lucian Freud

At twenty-one, Caroline Blackwood
fell in love with the married Lucian
Freud. Heiress to a massive fortune,
she abandoned a bevy of suitors in
London to move with him to
Paris and marry. He painted
many portraits of her,
chronicling the darkening
mood of their marriage,
which ended after a handful
of years. Lucian never remarried—
though he fathered several children
out of wedlock. Some said he never
recovered from heartbreak.

*Though Caroline was already an
accomplished essayist, it was her
disastrous marriage to **Robert Lowell**
that sparked her turn to fiction.*

Edmund Wilson, a renowned critic and essayist, spent his whole life in literary crowds. He was an early editor of **F. Scott Fitzgerald**, who he knew from Princeton, and lost his virginity to the poet Edna St. Vincent Millay. Edmund's 1944 review of **Anaïs Nin**'s *Under a Glass Bell*, a self-published effort with engravings from her husband, got her major early exposure and respect—and helped Edmund make his way onto Anaïs's roster of lovers.

Mary
McCarthy

Shortly after Mary published *The Group*, her bestselling novel about postcollegiate women in New York, **Elizabeth Hardwick** pseudonymously published a short parody, *The Gang*, in the *New York Review of Books*. Though Mary was offended, their close friendship endured.

In 1938, **Mary McCarthy** was living with Philip Rahv, literary critic and editor of the *Partisan Review*, when she abruptly left to marry Edmund. Almost ten years later, she published **The Oasis**, a satire of the self-important intellectual company Philip kept. Her ex-partner nearly brought a suit against her over a main character's close resemblance to him.

Mary and **Edmund**'s relationship, like all their previous relationships, was riddled with infidelity. For a time, Mary was seeing Clement Greenberg, a leading art critic. The identity of many of Edmund's lovers is lost to history. Expecting his journals would one day be public, he used pseudonyms.

Edmund
Wilson

Anaïs Nin

The thousands of pages of Anaïs Nin's diaries chronicle the life of a woman ahead of her time. Born in France to Cuban parents, she bounced around Europe and the United States, but it was in Paris that she discovered erotica and began writing her own, some of the first written by a woman. She was unapologetic about her sexual desires and affairs, and equally passionate about her life as a writer.

Anaïs's lovers continued

Married in 1947 in their native Minneapolis, **Louis & Bebe Barron** moved to Greenwich Village the same year and soon opened one of the city's first recording studios. Louis's cousin, who worked for 3M, had given them a tape recorder as a wedding present. He kept them supplied with magnetic tape when such technology was still a rarity. Louis built most of their equipment and Bebe did the bulk of the composing, creating some of the earliest electronic music. Their 1956 soundtrack for the sci-fi classic *Forbidden Planet* is considered the first entirely electronic film score—though it wasn't recognized as such. At the time, they weren't credited as composers but instead listed under Electronic Tonalities.

Louis and Bebe also had the idea to make recordings of writers reading their work. **Anaïs** recorded the entirety of her novel *House of Incest* with them. **Henry Miller**, Aldous Huxley, and **Tennessee Williams** also stopped by the studio.

Bebe Barron

Louis Barron

In the early '50s, Louis and Bebe were hired by **John Cage** to be the engineers on his *Williams Mix*. Cage was one of the first to consider their work to be a new art form unto itself.

In 1962, Louis and Bebe moved to Los Angeles. Though they divorced eight years later, they continued working together until Louis's death in 1989.

John Cage came to New York City in the '40s on heiress **Peggy Guggenheim**'s dime to perform at her gallery, and stayed in the apartment she shared with her husband, the painter **Max Ernst**. But when she found out he would also be giving a concert at MoMA, she told him she wouldn't pay for the transport of his instruments, which were still in Chicago.

He burst into tears. Marcel Duchamp, rumored to have had an ongoing affair with Peggy, sat there in a rocking chair, smoking a cigar as John wept. John later reported that Marcel said "virtually nothing, but his presence was such that I felt calmer."

John Cage

Marcel Duchamp

Savador Dalí *dedicated a custom chess set to Marcel. Most of the pieces were fingers or toes.*

See page 41

John and **Marcel** didn't become close until the latter was near the end of his life. John asked if Marcel might teach him chess, and started coming over to his and Teeny Duchamp's West Village apartment once or twice a week. Marcel mainly just smoked and watched him play Teeny, occasionally telling him how bad his game was. In 1968, the two men played a public game for a collaborative piece called *Reunion*. The chess board had been wired so that when they moved their pieces, random pieces of music would play. Between moves the auditorium was silent. Marcel won the game and died later that year.

Merce Cunningham

Merce began his career as a soloist with six years in the dance company of **Martha Graham**, the mother of modern dance, but left to start his own company, saying, "I wanted Dada, not Mama." The two barely spoke for the rest of their lives. When he died and his company dissolved (as was his dying wish), Martha's company (still intact many years after her death) moved into his former studio. They painted the austere white lobby a vivid orange.

John Cage was hired to play piano accompaniment for a Seattle dance class in which a young **Merce Cunningham** was a student. A menage à trois ensued between the two and John's then-wife, before Merce moved to New York to pursue his career. John eventually followed and the two men began their lifelong collaboration with the performance *Credo in US*. Both believed that no art form should be subordinate to another, so they composed and choreographed separately, bringing their songs and dances together at the last minute. They lived and worked together until John's death in 1992.

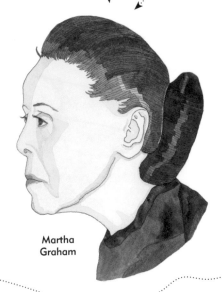

Martha Graham

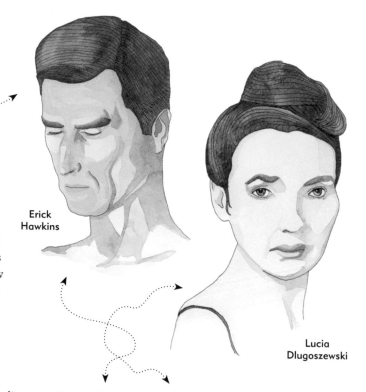

Erick Hawkins, the first male dancer in the Martha Graham Dance Company, was also **Martha**'s first and only husband. Their relationship became strained when Erick broke away to form his own company. They divorced a few years later, and ever after it pained Martha to watch young couples performing the duets they once danced together.

Erick Hawkins

Lucia Dlugoszewski

Soon after divorcing Martha, **Erick** met Lucia Dlugoszewski, a nontraditional composer who had studied with **John Cage**. Lucia and Erick collaborated and married a decade later, though they kept their union a secret until his death in 1994, after which she became the director of their company. During her five-decade career, Lucia received great recognition. **Frank O'Hara** was her first reviewer. John Ashbery and Willem de Kooning were fans. Robert Motherwell became such a close friend that she dedicated her last work, *Motherwell Amor*, to him. Lucia failed to show up to its premiere; she was later found in her apartment, dead of natural causes.

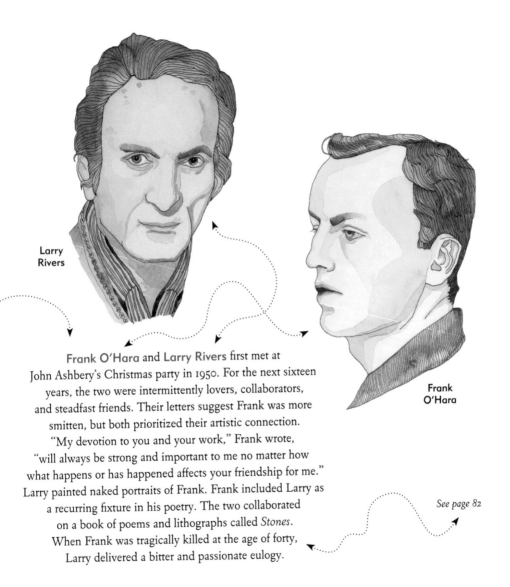

Larry
Rivers

Frank
O'Hara

Frank O'Hara and Larry Rivers first met at
John Ashbery's Christmas party in 1950. For the next sixteen
years, the two were intermittently lovers, collaborators,
and steadfast friends. Their letters suggest Frank was more
smitten, but both prioritized their artistic connection.
"My devotion to you and your work," Frank wrote,
"will always be strong and important to me no matter how
what happens or has happened affects your friendship for me."
Larry painted naked portraits of Frank. Frank included Larry as
a recurring fixture in his poetry. The two collaborated
on a book of poems and lithographs called *Stones*.
When Frank was tragically killed at the age of forty,
Larry delivered a bitter and passionate eulogy.

See page 82

The Books

Le pur et l'impur
Colette

Tropic of Cancer
Henry Miller

Quartet
Jean Rhys

*Written in a series of vignettes and conversations drawn from her circle of friends, **Colette** called this 1933 novel her most autobiographical. The poet **Renée Vivien**, whose real name appears in the text while others' were at least semifictionalized, was not amused. She is depicted as vapid and self-destructive.*

*It was after he began his affair with **Anaïs Nin** that **Henry Miller**, who had been writing without success for many years, finished his first great work, Tropic of Cancer. Anaïs helped edit the novel, and also borrowed money from her psychoanalyst to pay for the printing.*

*In the novel Quartet, based on her stormy affair with **Ford Madox Ford**, **Jean Rhys** named his character Heidler, a reference to his given last name, Hueffer.*

The Books

When the Wicked Man
Ford Madox Ford

Not to be outdone, **Ford** published his own account of their romance two years later. It's regarded as a revenge book and not Ford's finest. Both his wife and Jean's husband also published accounts of those years.

The Oasis
Mary McCarthy

Ten years after dumping Philip Rahv, editor of the Partisan Review, for **Edmund Wilson, Mary McCarthy** published The Oasis, a searing critique of Philip's intellectual circle. One character was such an unflattering, thinly veiled portrait of Philip that he almost brought a lawsuit against her.

The Dolphin
Robert Lowell

After leaving **Elizabeth Hardwick** for **Caroline Blackwood, Robert Lowell** produced a collection of poems, The Dolphin, that included direct excerpts from Elizabeth's heartbroken letters. In the American Poetry Review, Adrienne Rich, a friend of the former couple, called it "one of the most vindictive and mean-spirited acts in the history of poetry." The title was Robert's pet name for his new wife.

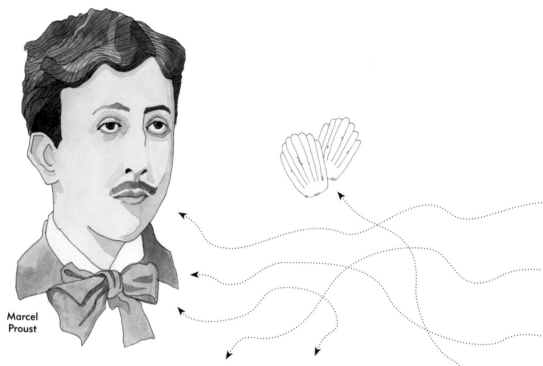

Marcel
Proust

When Reynaldo Hahn and Marcel Proust met in 1894,
Marcel had written very little, while Reynaldo, a Venezuelan-born
child prodigy, was already a celebrated musician and composer and
had just completed his first opera. The two collaborated on what
became Marcel's first book, *Pleasures and Days*. Though the
romantic aspect of their friendship was relatively brief, they
stayed in touch for decades, often corresponding in a secret code.
A trip they took along the Brittany coast seemingly inspired
many scenes from *In Search of Lost Time*.

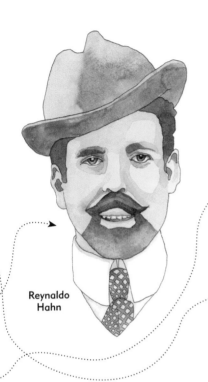

Reynaldo
Hahn

Though they never met, **Marcel** received a copy of **Natalie Clifford Barney**'s *Pensées d'une Amazone* inscribed to the young writer. "To Marcel Proust, whose understanding merits this unexpurgated copy—between pages 72 and 73— . . . where he will find himself mentioned." The pages she refers to depict a sexual relationship between Socrates and Alcibiades. Marcel called the book "ravishing and profound."

Élisabeth de Gramont is said to have inspired a minor character in Marcel's *In Search of Lost Time.*

[CHAPTER TWO]

The Love That Dare Not Speak Its Name

The affair between **Renée** and **Natalie** was short, intense, and painful. After they broke up, Natalie continually tried to get her back, writing ardent poems and letters.

Colette's novel *The Pure and the Impure* included a mistress-and-slave relationship based on that of Renée and Natalie.

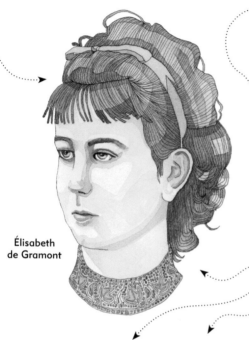

Élisabeth de Gramont

Renée Vivien

Natalie Clifford Barney met Élisabeth de Gramont in 1909, the same year that Renée Vivien, another lover, passed away. Natalie was already committed to non-monogamy, or, as Élisabeth later described it, "indifferent to everything except the free play of her life." The two bonded over astrology and tarot, and, though Élisabeth was married with two children, began a love affair that lasted the rest of their lives.

Natalie Clifford Barney

Natalie was a prolific writer, producing five books of poetry, three books of epigrams, three memoirs, a novel, and two collections of essays. She also had so many lovers that **Alice B. Toklas** once quipped she must have been picking them up in department store lavatories. Rebellious from a young age, Natalie settled in Paris in her mid-twenties and began hosting weekly salons, bringing together everyone from **Isadora Duncan** to **Jean Cocteau**. She is credited with repopularizing Sappho among this creative elite. She was briefly engaged to writer **Lord Alfred Douglas** and had an ongoing affair with Dolly, notorious niece of **Oscar Wilde**—who himself had an affair with Lord Alfred.

In 1916, Natalie met painter **Romaine Brooks**. Élisabeth grew deeply jealous and briefly fled to Paris. To appease her, Natalie wrote up a marriage contract (though Élisabeth wasn't legally divorced from her husband for another two years). Both Romaine and Élisabeth continued their non-monogamous relationships with Natalie until Élisabeth's death in 1954.

Romaine Brooks, lover to **Natalie Barney** for over fifty years, said she slightly preferred being with Natalie to being alone, and preferred being alone to being around almost anyone else. Tolerating Natalie's affairs but never keeping pace, Romaine spent most of her time brooding in her studio, painting portraits that were lauded at the time but are rarely displayed today. Romaine also wrote an autobiography, called *No Pleasant Memories*, which told of a childhood so bleak that no publisher believed it could be true.

Lord
Alfred
Douglas

Romaine
Brooks

In her early twenties, **Natalie** was briefly engaged to Lord Alfred Douglas, but her father was so repulsed by the prospect of their marriage that he stopped pressuring her to marry altogether. **Romaine** also had a brief affair with Lord Alfred in Capri. He inscribed a book of his poetry to her, "We have often told each other imperishable things."

Zelda Fitzgerald *also met* Romaine *in Capri.*

See page 51

When they fell in love in 1891, **Oscar Wilde** was already one of the most popular playwrights in London and **Lord Alfred Douglas** was a budding poet: beautiful, sixteen years his junior, and married with two kids. Lord Alfred's concerned father began to harass Oscar, even planning to pelt him with vegetables at the premiere of *The Importance of Being Earnest*. Eventually, Oscar was put on trial for acts of "gross indecency." Among the evidence was Lord Alfred's poem "Two Loves" and a satirical novel of their affair, *The Green Carnation*—published anonymously but written by their friend Robert Hichens. Oscar served two years in jail and died in 1900, separated from Lord Alfred for the last three years of his life.

Walt
Whitman

Oscar
Wilde

When **Oscar** was sent on a lecture tour through America in 1882, he immediately asked if he could meet **Walt Whitman**, whose work he'd long admired. The two spent some hours alone in Whitman's den where, the poet said, they could "be on 'thee and thou' terms." They spoke of literature and literary fame, and Walt gave Oscar a portrait of himself. Oscar later arranged a second meeting before his return to London. "There is no one in this wide great world of America whom I love and honour so much," he wrote. Walt later described Oscar as "a fine large handsome youngster."

The Talk

Grace Paley on **Kay Boyle:**

———

"People with full sex lives
don't have regrets."

Alice B. Toklas *on* **Mercedes de Acosta:**

———

"Say what you will about Mercedes,
she's had the most important women
of the twentieth century."

Edmund Wilson *on* **Zelda Fitzgerald:**

———

"I have rarely known a woman who expressed
herself so delightfully and so freshly:
she had no ready-made phrases on the
one hand and made no straining
for effect on the other."

Tallulah Bankhead:

———

"My father warned me about men
and booze but he never said anything
about women and cocaine."

Jean Cocteau *on* **Pablo Picasso** *and* **Dora Maar:**

———

"Picasso is a man and a woman deeply entwined…
a living ménage…Dora is a concubine with whom
he is unfaithful to himself. From this ménage,
marvelous monsters are born."

The Talk

Elizabeth Hardwick *on* Billie Holiday:

———————

"Her whole life had taken place in the dark....
Night-working, smiling, in make-up, in long,
silky dresses, singing over and over,
again and again."

Zora Neale Hurston:

———————

"Love makes your soul crawl
out from its hiding place."

James Baldwin *on coming out:*

———————

"Best advice I ever got was an old friend of mine,
a black friend, who said you have to go the way
your blood beats. If you don't live the only
life you have, you won't live some other life,
you won't live any life at all. That's the only
advice you can give anybody. And it's
not advice, it's an observation."

Peggy Guggenheim *on how she ended her
"eighteen months of frustration" with Samuel Beckett:*

———————

"I remember saying to him one day, 'Oh dear,
I forgot that I was no longer in love with you.'
I think it was the result of having consulted a
fortune teller. She seemed to think it was the
moment to marry him or give him up.
She said he was an awful autocrat."

Martha Gellhorn *on* Ernest Hemingway:

———————

"No woman should ever marry
a man who hated his mother . . .
[He had a] mistrust and fear of women.
Which he suffered from always, and
made women suffer; and which
shows in his writing."

27

Louis
Armstrong

Music Is
My Mistress

Though women were rarely a part of jazz ensembles at the time, **Lil Hardin**'s talent and ambition as a pianist quickly earned her a decent living and the nickname "Hot Miss Lil." Both she and **Louis Armstrong** were married to other people when they met, but after each divorced, they began dating and married each other in 1924. Lil soon "took the country out of" Louis, changing his clothes and hairstyle, and began writing songs with him. Though they were a collaborative success, their relationship was rocked by Louis's infidelities. Their divorce settlement in 1938 awarded Lil rights to the songs they'd co-composed, but she had grown tired of music by then, and began designing and sewing clothes. Meanwhile, Louis's fame reached great heights, and his new collaborators included **Duke Ellington** and **Ella Fitzgerald.** He even played himself in the 1947 movie *New Orleans*, starring opposite **Billie Holiday.** Though they had been divorced many decades, Lil performed at a memorial concert for Louis shortly after his death.

See page 83

Tallulah Bankhead *was a huge admirer of Louis and was obsessed with his recording of "Potato Head Blues." She played it backstage to get amped up before performing.*

See page 69

Lil Hardin Armstrong

Duke Ellington's lasting impression on American music is one of the most significant of the twentieth century. His collaborations with **Ella Fitzgerald** and **Louis Armstrong** produced some of the most recognizable jazz of the era. He toured with **Django Reinhardt** through America in 1946.

Duke titled his autobiography *Music Is My Mistress*, but music certainly wasn't the only one. At times he would book a few rooms in different hotels, hand out keys to women he met through the night, and only later decide which one to visit.

Duke Ellington

Ray Brown

In 1972, **Duke** and Ray Brown recorded *This One's for Blanton!* an album of piano and bass duets dedicated to Jimmy Blanton, a double-bass virtuoso with Duke's band who died of tuberculosis at the age of twenty-three.

*Duke was friends with the French writer **Boris Vian** and the godfather to his daughter. The English translation of one of Boris's novels took its title from Duke's song "Mood Indigo."*

See page 55

Ray met **Ella Fitzgerald** when she joined him in Dizzy Gillespie's band during a 1947 tour. They were married for just five years, but Ray continued to be her musical director after the divorce.

Ella Fitzgerald recorded over two hundred albums and won thirteen Grammys in her lifetime. Her famous "songbook" recordings elevated the careers of composers such as **Duke Ellington**, Cole Porter, and George and Ira Gershwin. Ira said he never knew how beautiful their songs could be until he heard Ella sing them.

Her talent for heartbroken ballads may have had roots in her handful of troubled romances. Her marriage to **Ray Brown** was strained by their successful careers. While touring Europe, Ella fell in love with a younger man from Norway, Thor Einar Larsen, but she eventually realized that he was taking advantage of her. In any case, he'd stolen money from a previous fiancée and the charges against him made it impossible for him to go back to America with Ella.

Ella
Fitzgerald

Marilyn Monroe was an early fan of Ella's and convinced the owner of the Mocambo, a popular L.A. nightclub in the '50s, to book her for a series of concerts, telling him that she would sit at the front of the club every night Ella played. Ella was forever thankful, and called Marilyn "an unusual woman, a little ahead of her times, and she didn't know it."

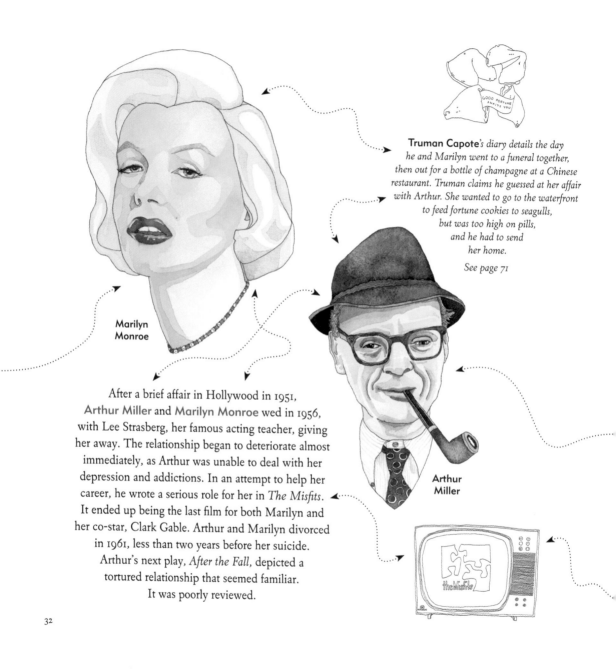

Truman Capote's diary details the day he and Marilyn went to a funeral together, then out for a bottle of champagne at a Chinese restaurant. Truman claims he guessed at her affair with Arthur. She wanted to go to the waterfront to feed fortune cookies to seagulls, but was too high on pills, and he had to send her home.

See page 71

Marilyn
Monroe

Arthur
Miller

After a brief affair in Hollywood in 1951, Arthur Miller and Marilyn Monroe wed in 1956, with Lee Strasberg, her famous acting teacher, giving her away. The relationship began to deteriorate almost immediately, as Arthur was unable to deal with her depression and addictions. In an attempt to help her career, he wrote a serious role for her in *The Misfits*. It ended up being the last film for both Marilyn and her co-star, Clark Gable. Arthur and Marilyn divorced in 1961, less than two years before her suicide. Arthur's next play, *After the Fall*, depicted a tortured relationship that seemed familiar. It was poorly reviewed.

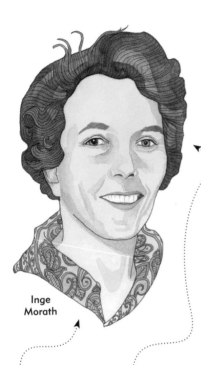

Inge
Morath

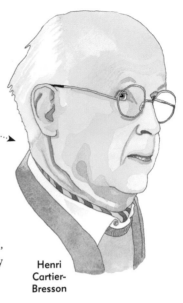

Henri
Cartier-
Bresson

Inge was originally hired as an editor for the Paris-based photography collective Magnum, and said she learned photography from looking at Henri's images long before she picked up a camera. She soon became one of the first female members of Magnum. In addition to her street photography, she photographed several Hollywood sets.

Henri Cartier-Bresson and Inge Morath were two of the photographers hired to be on set for the filming of *The Misfits*. Arthur Miller married Inge shortly after his divorce from Marilyn, though he claimed their relationship didn't start until after filming.

The origin of **Henri**'s photography career can be traced back to the wild publisher and poet **Harry Crosby**, who gave Henri his first camera. At the same time, Henri began an intense affair with **Caresse Crosby**, Harry's wife. Afterward, his brokenhearted wanderlust spurred his photography practice.

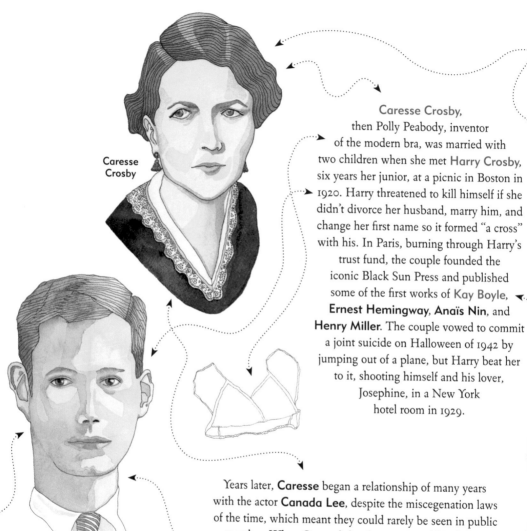

Caresse Crosby

Caresse Crosby, then Polly Peabody, inventor of the modern bra, was married with two children when she met **Harry Crosby**, six years her junior, at a picnic in Boston in 1920. Harry threatened to kill himself if she didn't divorce her husband, marry him, and change her first name so it formed "a cross" with his. In Paris, burning through Harry's trust fund, the couple founded the iconic Black Sun Press and published some of the first works of **Kay Boyle**, **Ernest Hemingway**, **Anaïs Nin**, and **Henry Miller**. The couple vowed to commit a joint suicide on Halloween of 1942 by jumping out of a plane, but Harry beat her to it, shooting himself and his lover, Josephine, in a New York hotel room in 1929.

Harry Crosby

Years later, **Caresse** began a relationship of many years with the actor **Canada Lee**, despite the miscegenation laws of the time, which meant they could rarely be seen in public together. When Caresse's brother expressed his dismay at the relationship she cut off almost all contact with him for a decade.

Caresse and Harry Crosby published **Kay Boyle**'s first book, *Short Stories*, at Black Sun Press, and when Kay needed money for an abortion, Harry paid. **Edmund Wilson** insulted her 1944 novel *Avalanche*, calling it "feminized Hemingway."

Kay married **Peggy Guggenheim**'s ex-husband, Laurence Vail. Kay, Laurence, Peggy, and Peggy's new lover, **Max Ernst**, who had just left an internment camp in France, fled Europe together for America at the start of World War Two.

Peggy
Guggenheim

A great supporter of the arts, **Peggy** had a tortuous relationship with Samuel Beckett, had her portrait taken by **Man Ray**, and married **Max Ernst**. **Anaïs Nin** brought **Gore Vidal** to one of her infamous parties and he became a good friend as well, though, as Gore says in the forward to Peggy's memoirs, "Peggy never liked Anaïs."

Kay
Boyle

*Peggy met **Marcel Duchamp** in Paris in the '20s through her first husband, and there was speculation of an affair. He was her first guide to the Parisian art scene.*

See page 14

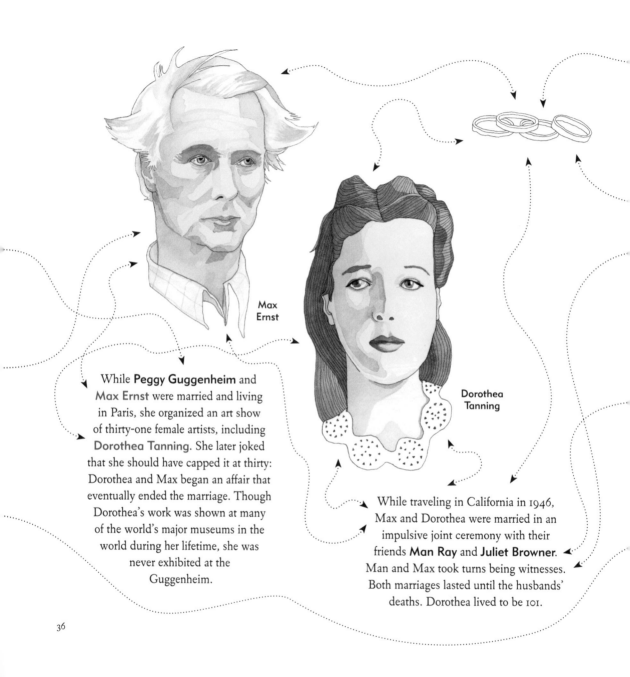

Max
Ernst

Dorothea
Tanning

While **Peggy Guggenheim** and
Max Ernst were married and living
in Paris, she organized an art show
of thirty-one female artists, including
Dorothea Tanning. She later joked
that she should have capped it at thirty:
Dorothea and Max began an affair that
eventually ended the marriage. Though
Dorothea's work was shown at many
of the world's major museums in the
world during her lifetime, she was
never exhibited at the
Guggenheim.

While traveling in California in 1946,
Max and Dorothea were married in an
impulsive joint ceremony with their
friends **Man Ray** and **Juliet Browner**.
Man and Max took turns being witnesses.
Both marriages lasted until the husbands'
deaths. Dorothea lived to be 101.

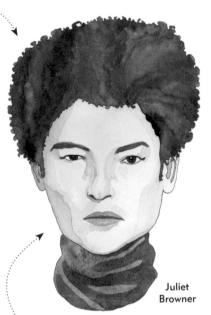

**Juliet
Browner**

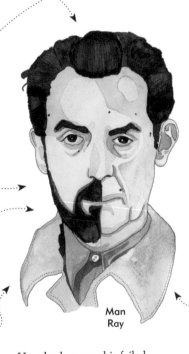

**Man
Ray**

Juliet Browner, an artist and muse for Man
Ray until his death, grew up in New York and
studied dance with **Martha Graham**, but found
the work of an artist's model much easier:
"I would just strike a pose and hold it."
She had a previous live-in relationship with
Willem de Kooning, who also painted her, but
once she met Man in 1940 they were inseparable.
She was twenty-nine. He was fifty. They lived in
Hollywood through the '40s and moved to
Paris in 1951. She changed her name to
Juliet Man Ray in marriage.

Heartbroken over his failed
relationship with photographer
Lee Miller, his former assistant,
Man Ray created some of his most
memorably melodramatic works,
including the iconic photographs
of glass tears balanced on a
mannequin's face.

37

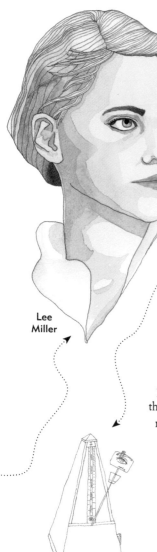

Lee Miller

Lee Miller was already an artist when Condé Nast himself discovered her and began her modeling career, which she gave up to work as **Man Ray**'s assistant in Paris. They quickly became lovers, and she discovered the solarization technique that Man used for the rest of his career. Her lips and eyes are the subject of many photographs and paintings, and it's her eye on the swinging arm of the metronome in his readymade *Indestructible Object*. After their breakup, it took some years to recover a friendship, but it lasted until his death.

Lee and **Pablo Picasso** became friends while vacationing in the same group in 1937. Pablo painted a few portraits of her; Lee took many photographs of him. It seems the relationship was occasionally romantic, most likely with her husband, Roland Penrose's consent, who was later Pablo's biographer.

Lee went on to be a hugely successful photojournalist, the only person to be both cover girl and war photographer for *Vogue*. She documented several pivotal moments of World War II, including the London Blitz and the liberation of Paris. David Scherman, a photographer for *LIFE*, took an iconic photograph of Lee in Hitler's bathtub. But after the war, Lee was depressed, traumatized, and likely annoyed by her husband's ongoing affair with a trapeze artist. Her last piece for *Vogue* was a photo series called *Working Guests*, which included a photograph of **Max Ernst** doing some gardening.

The poet **Paul Éluard** introduced Dora Maar to **Pablo** while she was working as a set photographer for Jean Renoir. Pablo was technically married and had recently fathered a daughter with one of his mistresses, but he was, predictably, shaken by the twenty-eight-year-old's intelligence and beauty. In the café where they met, she was stabbing a penknife between her spread fingers when she apparently missed and drew blood, staining a pair of gloves. Pablo asked to keep them.

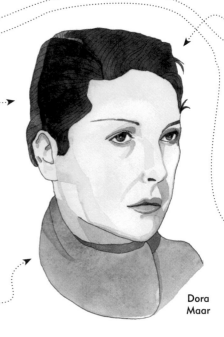

Dora
Maar

Dora's photographs of the Spanish Civil War were hugely influential to Pablo's *Guernica*. She painted a few minor parts of the iconic mural. Picasso's many famous portraits of Dora include *The Weeping Woman*. For her part, she gave up photography during their relationship, which was fraught. At one point, a rival mistress showed up at Pablo's studio and demanded Dora leave. Pablo wouldn't take sides, leaving the women to wrestle on the floor.

After ten years as Pablo's primary love, Dora converted to Catholicism, saying, "After Picasso, Only God."

Pablo
Picasso

39

Several of **Dora Maar**'s photographs and paintings of Nusch suggest a romance between the two. Nusch also had an affair with Pablo (with Paul's consent). **Lee Miller** took one of the last known portraits of her in 1944—two years before Nusch's sudden death.

The surrealist poet **Paul Éluard** met his first wife, **Gala Dalí**—then Elena Diakonova—in a sanatorium, where both were teenagers fighting tuberculosis. Reunited a few years later, they married. **Max Ernst** later became a third part of the relationship. Paul and Max collaborated on several books together, but eventually the triad dissolved and Gala left Paul for **Salvador Dalí**.

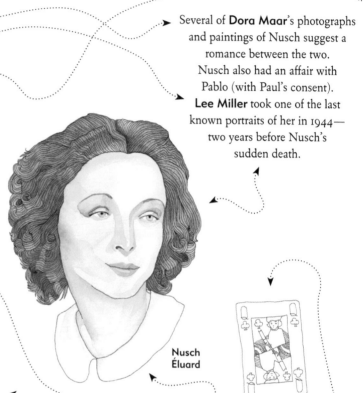

Nusch Éluard

Paul Éluard

Man Ray introduced **Paul** to the future **Nusch Éluard**, an actress and model recently arrived from Zurich. She made surrealist collages and was fond of wandering the streets of Paris alone, wearing a mask, and she inspired much of Paul's poetry. In a deck of surrealist-photo playing cards, Man Ray made Nusch the Queen of Clubs.

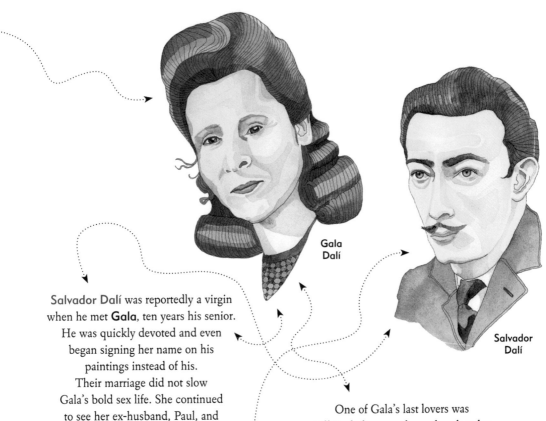

Gala
Dalí

Salvador
Dalí

Salvador Dalí was reportedly a virgin
when he met **Gala**, ten years his senior.
He was quickly devoted and even
began signing her name on his
paintings instead of his.
Their marriage did not slow
Gala's bold sex life. She continued
to see her ex-husband, Paul, and
he continued to write her raunchy,
romantic letters. Salvador was
apparently unbothered.

One of Gala's last lovers was
Jeff Fenholt, more than a few decades
her junior. He played Jesus in the original
Broadway production of *Jesus Christ Superstar*,
and was a short-lived member of Black Sabbath.
Fenholt later became a televangelist and renounced
his years of sex, drugs, and rock and roll.

The Letters

Frank O'Hara *to* Larry Rivers:

"Someone who didn't like me could say, 'Sure, all you have to do is show him Larry Rivers or the sea, and out comes a poem;' but really, I don't see why one shouldn't enjoy something in life if one can stand not enjoying so much else. it's too bad you don't imagine I understand you as well as I imagine you understand me, but we can't have everything at the same time, thank god, or it would be too confusing…"

Gore Vidal *to* Anaïs Nin:

"You are quite necessary to me as you know . . . I have adjusted myself to the fact that I shall never have a satisfying homosexual relationship. I am attracted to youth, to beauty, and separately, unphysically, to you, to the spiritual emotional rapport we have had. I need that more than the other. I cannot, and this is strange, do without women."

Larry Rivers *to* Frank O'Hara:

"I'm not equaling your desire to see me with a desire to see you."

The Letters

Billie Holiday's *response to* **Tallulah Bankhead**,
who felt slighted by her portrayal in Billie's memoir:

"There are plenty of others around who remember how
you carried on so you almost got me fired out of the [Strand].
And if you want to get shitty, we can make it a big shitty party.
We can all get funky together!...Read my book over again...
There's nothing in it to hurt you. Straighten up and fly right,
Banky!"

Natalie Clifford Barney *to* **Renée Vivien:**

"Should I bang on her closed door?
Dare to send her a more direct
poem, reveal to her my suffering,
how much I was suffering?
Swallow my pride and admit
that I loved her still, since I could
not help but be faithful to her?"

Frida Kahlo *to* **Georgia O'Keeffe:**

"I thought of you a lot and never forget
your wonderful hands and the color
of your eyes. I will see you soon.
I am sure that in New York I will be
much happier. If you [are] still in the
hospital when I come back I will bring
you flowers, but it is so difficult to find
the ones I would like for you. I would
be so happy if you could write me
even two words. I like you very much
Georgia."

The Stud File

Samuel Steward was a poet, novelist, academic, diarist, tattoo artist, and pornographer. As a young man in the 1930s, he headed to Europe, fell in with **Gertude Stein**'s crowd, and managed to seduce Thornton Wilder, **Lord Alfred Douglas**, and Thomas Mann, among others. He documented these and almost every other sexual encounter of his life in 746 entries in his "Stud File," some of them with smears of physical evidence. When Samuel met Alfred Kinsey, his meticulously documented sex life became a prime source for the infamous sexologist.

Samuel Steward

See page 82

See page 26

Alice B.
Toklas

Gertrude
Stein

The salons hosted at the Paris apartment of partners Gertrude
Stein and Alice B. Toklas were a meeting ground for almost
every artist in this book, including **Mercedes de Acosta**
and **Isadora Duncan**. Gertrude published many books,
including *The Autobiography of Alice B. Toklas*—which **Ernest
Hemingway**, ostensibly a friend, called "a damned pitiful book."
Gertrude and Alice stayed in Paris through the war and drove an
ambulance together. Alice's memoir, *What Is Remembered*,
ends abruptly with Gertrude's death.

Gertrude was an early collector of
Pablo Picasso's work, and Pablo
painted Gertrude's portrait. When
someone told him that it didn't look
like her, his response was, "It will."
Twenty years later, Stein wrote
a poem titled "If I Told Him: A
Completed Portrait of Picasso."

See page 39

Richard met a young **James Baldwin** *in the early '40s and nominated the budding writer for a fellowship, which he won. James returned the favor with a 1949 essay denouncing Richard's hugely successful* Native Son *for its "rejection of life," and reliance on destructive stereotypes. The essay was collected in James's* Notes of a Native Son, *and he later recalled defending the critique to Richard: "All literature might be protest, but not all protest [is] literature."*

See page 64

Richard Wright began reading and writing about **Gertrude Stein**'s work in the '30s, citing her as an early influence. In the '40s, Gertrude began publicly praising Richard's work in return, and the two began a correspondence. Just after the war, when the U.S. State Department denied Richard a passport to travel to Paris, Gertrude had the French government send a formal invitation. She died shortly after he arrived. They are buried near each other in the Père Lachaise Cemetery.

Richard
Wright

Along with **Langston Hughes**, *Theodore Ward, and several others, Richard founded the short-lived Negro Playwrights Company in 1940.*

See page 65

Mercedes
de Acosta

Though **Mercedes de Acosta**'s plays were performed in Paris and New York, she struggled to make headway in her career. She moved to Hollywood to try to write screenplays, meeting **Greta Garbo** in 1931. The two fell quickly and passionately in love: there were trips together, trysts on the beach, naked portraits. But Greta was uneasy being publicly identified as a lesbian. Frustrated by Greta's inability to commit, Mercedes had a side affair with Marlene Dietrich. Still, she and Greta were on-again-off-again for more than twenty years.

Marlene
Dietrich

In the 1960s, broke and needing brain surgery, Mercedes wrote a memoir called *Here Lies the Heart* that detailed her close relationship with "a crazy mystic Swede." Greta was furious. Shortly after publication, they ran into each other at a grocery store. Mercedes asked, "Aren't we on speaking terms today?" Greta left without a word, and the two never spoke again, though some report seeing Greta lurking outside Mercedes's funeral in 1968.

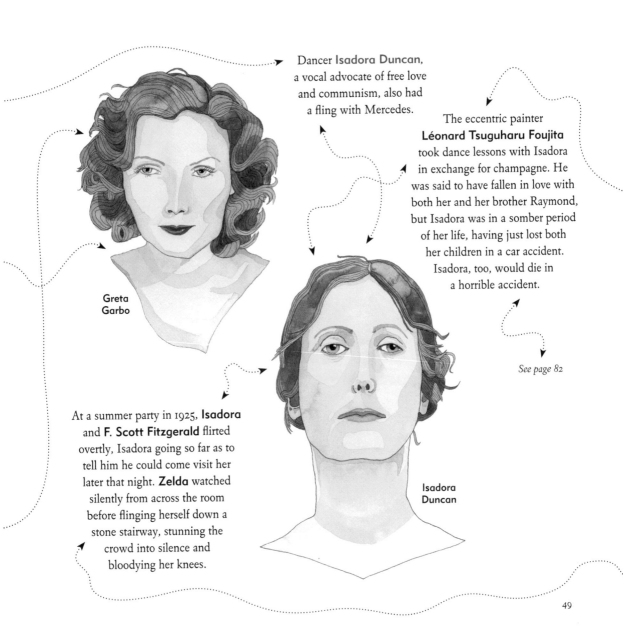

Dancer **Isadora Duncan**,
a vocal advocate of free love
and communism, also had
a fling with Mercedes.

The eccentric painter
Léonard Tsuguharu Foujita
took dance lessons with Isadora
in exchange for champagne. He
was said to have fallen in love with
both her and her brother Raymond,
but Isadora was in a somber period
of her life, having just lost both
her children in a car accident.
Isadora, too, would die in
a horrible accident.

See page 82

Greta
Garbo

At a summer party in 1925, **Isadora**
and **F. Scott Fitzgerald** flirted
overtly, Isadora going so far as to
tell him he could come visit her
later that night. **Zelda** watched
silently from across the room
before flinging herself down a
stone stairway, stunning the
crowd into silence and
bloodying her knees.

Isadora
Duncan

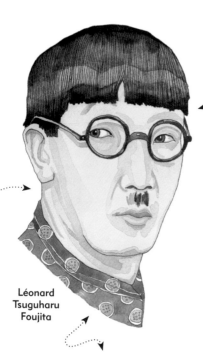

Kiki de Montparnasse modeled for every artist in Paris in the 1920s. **Fou Fou** drew her. **Man Ray** immortalized her in his famous photograph that transforms her into a cello. Alexander Calder made a sculpture of her nose called *Kiki's Nose*. When she was arrested for punching a police officer, Man bailed her out. On a trip to New York in 1923, Kiki was scheduled for a screen test for Paramount, but skipped it when she couldn't find her comb. "It's much nicer to go to the movies than make them," she later said.

See page 37

Fou Fou wrote a foreword and **Ernest Hemingway** *wrote a preface to Kiki's memoirs, written when she was just twenty-eight years old.*

See page 8

Léonard Tsuguharu Foujita

Léonard Tsuguharu Foujita, a painter from Japan known as Fou Fou (*fou* is French for *mad*), was extremely popular in France in the 1920s. He cross-dressed often and thought of his ensembles and persona as an ongoing work of art, one so well-known that mannequins in Paris storefronts were sometimes dressed in homage. He painted a tremendous number of cats.

Kiki de Montparnasse

Of their shared interest in sailors, **Kiki** *quipped "[Jean]* **Cocteau** *and I had the same passion for all that comes from the sea." Fou Fou and Jean were also friends. A surviving picture shows them holding an award-winning cat at a Paris cat show.*

See page 56

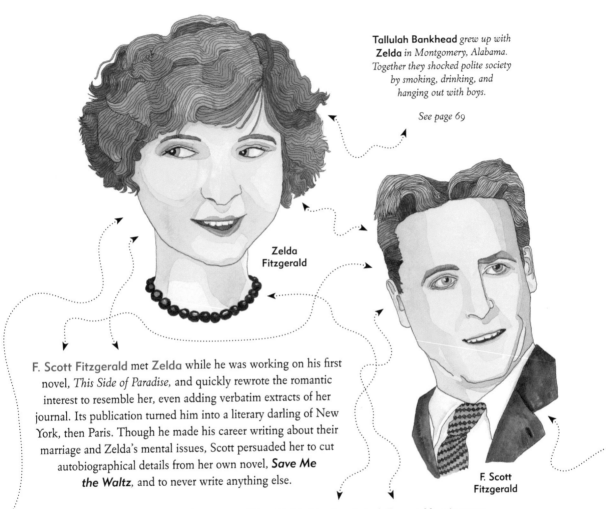

Tallulah Bankhead *grew up with* Zelda *in Montgomery, Alabama. Together they shocked polite society by smoking, drinking, and hanging out with boys.*

See page 69

Zelda Fitzgerald

F. Scott Fitzgerald

F. Scott Fitzgerald met Zelda while he was working on his first novel, *This Side of Paradise*, and quickly rewrote the romantic interest to resemble her, even adding verbatim extracts of her journal. Its publication turned him into a literary darling of New York, then Paris. Though he made his career writing about their marriage and Zelda's mental issues, Scott persuaded her to cut autobiographical details from her own novel, **Save Me the Waltz**, and to never write anything else.

Zelda suspected Scott of having an affair with his friend and rival, **Ernest Hemingway**. While on vacation in Capri, Zelda became friends with the moody portrait artist **Romaine Brooks** and her circle of artist friends. When they later met some of this group in Paris, Scott was enraged by a pass that Dolly Wilde made at Zelda, and wrote a scene about it in **Tender Is the Night**, though it was ultimately cut.

51

*A young **Juliette Gréco** was a big fan of **Django**. She said she "dreamed of being his guitar."*

Django
Reinhardt

Born in Belgium in 1910 and raised mostly on the road, Django Reinhardt was a self-taught guitarist. After losing two fingers in a caravan fire at age eighteen, he had to reteach himself. He never learned to read or write, but his songs, blending Roma musical traditions with jazz, remain some of the most influential of the twentieth century.

Ada
"Bricktop"
Smith

Ada "Bricktop" Smith met **Langston Hughes** in Paris in 1924, at the first nightclub where she ever performed. He was working there as a busboy. Social and magnetic, **Ada** soon opened her own Chez Bricktop, a favorite spot for **Gertude Stein** and **Ernest Hemingway**, where she booked the likes of **Louis Armstrong**, **Duke Ellington**, and **Django**. **F. Scott Fitzgerald** once said, "My greatest claim to fame is that I met Bricktop before Cole Porter." **Django** wrote a song about her called "Bricktop."

Ada *and* **Josephine Baker** *were lovers—or so she told Josephine's son.*

See page 6

52

The young singer and actress Juliette Gréco was already a muse for **Jean-Paul Sartre** and a close friend of the writer **Boris Vian** when she met Miles Davis backstage at his first Paris concert. Michelle Vian, wife of Boris, introduced them and despite a language barrier, the two were smitten by the end of the night. They were together for a couple years before Miles returned to the States and fell into a depression, leading to his Blue Period.

Juliette and **Miles** later met up in New York, where the hostility they received in public was a rude awakening. Still, they kept touch the rest of their lives. Juliette wrote, "He would leave messages for me in the places I travelled in Europe: 'I was here, you weren't.'"

Juliette
Gréco

Miles Davis

Jean-Paul Sartre asked Miles why he didn't marry Juliette. He said he loved her too much to make her unhappy.

53

Jean-Paul Sartre asked Simone de Beauvoir to marry him when they were in their early twenties, but she preferred their open relationship. It lasted half a century.

Jean-Paul Sartre

Simone de Beauvoir

Simone's novel *She Came to Stay* was dedicated to Olga Kosakiewicz, her student who also formed a triad relationship with her and Jean-Paul. Olga's sister Wanda also had a separate relationship with Jean-Paul, and once pulled a gun on Simone. Several of Jean-Paul's exes suffered psychotic episodes and suicide attempts. Michelle Vian, who ended up divorcing **Boris** to be with **Jean-Paul,** stayed with him for the rest of his life, but also tried to kill herself.

Simone had an intense affair with writer Nelson Algren in 1949, though it was doomed by the distance between Chicago and Paris. Simone fashioned the main character of her novel ***The Mandarins*** after Nelson. He was later dismayed when he read her memoir and realized how dishonest she'd been with him.

Albert Camus was
Truman Capote's editor at the French
publisher Gallimard; Truman suggested they
became lovers. Albert Camus was also a close friend
and sometimes enemy of **Jean-Paul**, the two often
embroiled in intellectual debates. Fellow playwright
Jean Cocteau once wrote to **Albert** to commend a play
of his that received mixed reviews but Albert had long ago
written of his detest for Jean's novels. Jean later directed
María Casarès, an actress who had a sixteen-year
affair with Albert, in *Orphée*.

Albert
Camus

See page 30

Boris Vian

Boris Vian produced several books of fiction and
poetry and translated Raymond Chandler before
his death at 39. **Duke Ellington**, whose music
had been an inspiration to him since he was a
teenager, became a good friend and the godfather
to Boris's daughter when he visited Paris in the
late '40s. **Juliette Gréco** said Boris was
something of an older brother to her.

Jean Cocteau

Jean Cocteau
directed **Juliette Gréco**
in *Orphée*. He is best known
for his many films, novels,
and books of poetry,
but he also was a muse
and model for many visual
artists, including Modigliani,
Léonard Tsuguharu Foujita,
Romaine Brooks, and
Pablo Picasso.

Jean
Marais

Jean Cocteau was twice Jean Marais's age when
they met; the two Jeans would be inseparable for
the next quarter of a century. Marais was a strikingly
handsome actor, and later the cover boy for the
Smiths album *This Charming Man*.
Cocteau reduced his opium use after they met,
finding a new source of inspiration in his lover, whom
he cast in many of his films. The Jeans were credited
with being one of the first openly gay couples, and they
survived the Nazi occupation of Paris together.

Jean Cocteau knew **Proust**
when they were young men.
He was also a very close
friend of Edith Piaf's toward
the end of their lives.

See page 72

See page 82

As a young man, **Jean Cocteau** went on a vacation with a group including **Gertrude Stein** and Coco Chanel, bothering Coco with the amount of opium he smoked with his lover at the time. Coco became a morphine addict late in life. Jean wrote librettos for Igor Stravinsky's *Oedipus Rex*.

Coco Chanel

Igor Stravinsky

When **Coco** first met **Igor**, introduced by a collaborator they had in common, Ballets Russes founder Sergei Diaghilev, she said he "looked like a clerk in a Chekov short story." But when she later housed Igor and his family for several months, they ended up having an affair—at least according to Coco, who also said he was terribly jealous and heartbroken when she wouldn't accept his marriage proposal. He left for Spain with Ballets Russes in 1921, and though Coco was planning to meet them there, Sergei sent a telegram: "Don't come, he wants to kill you." The two never spoke again.

The Books

The Mandarins
Simone de Beauvoir

Giovanni's Room
James Baldwin

Save Me the Waltz
Zelda Fitzgerald

In this autobiographical novel about intellectuals in postwar Paris, the characters are rather obviously based on **Jean-Paul Sartre**, *Arthur Koestler, Nelson Algren,* **Albert Camus**, *and* **Simone** *herself. Nelson and Simone's characters, as they did in life, have an affair.*

James Baldwin *dedicated his second novel, Giovanni's Room, to his on-again-off-again lover,* **Lucien Happersberger**. *The novel features a young white man torn between his male lover and his female fiancée, just as Lucien bounced between James and his wife and son.*

When **F. Scott Fitzgerald** *read an early draft of Save Me the Waltz, he forced Zelda to take out some autobiographical details; he wanted to use them in Tender Is the Night. She named a character Amory Blaine, after the protagonist of Scott's first novel.*

The Books

Tender Is the Night
F. Scott Fitzgerald

L'écume des jours
Boris Vian

a: a novel
Andy Warhol

Deleted scenes from Tender Is the Night *include a semifictionalized account of the night that Dolly Wilde (**Oscar Wilde**'s niece) made a pass at* **Zelda** *in front of her husband.*

Boris Vian's 1946 novel L'écume des jours *was excerpted in* **Jean-Paul Sartre**'s *literary journal the same year. The direct translation of the title is* The Scum of the Days, *but its most recent English translation is* Mood Indigo, *a title taken from the* **Duke Ellington** *album.*

An almost verbatim transcript of tapes recorded by people hanging out in and around the Factory, the novel refers to several Warhol collaborators and friends by pseudonyms: **Edie Sedgwick** *is Taxi and Andy is Drella, a nickname* **Lou Reed** *gave him. Lou is also a voice in the book, as is the photographer Stephen Shore, and* **Ondine**. *Warhol intended to make a "bad novel." (Many felt he succeeded.)*

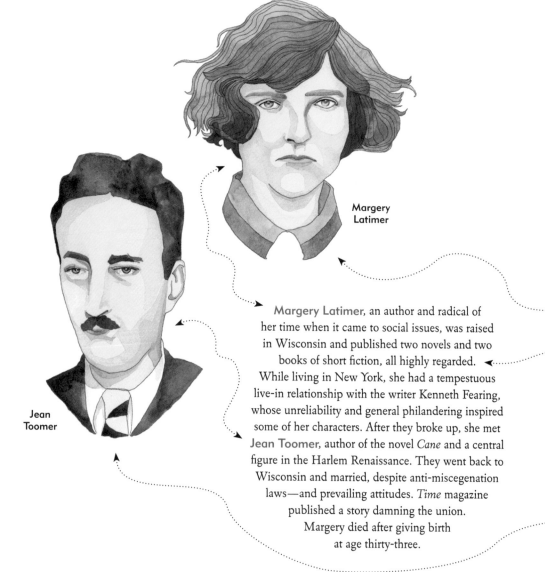

Margery
Latimer

Jean
Toomer

Margery Latimer, an author and radical of her time when it came to social issues, was raised in Wisconsin and published two novels and two books of short fiction, all highly regarded. While living in New York, she had a tempestuous live-in relationship with the writer Kenneth Fearing, whose unreliability and general philandering inspired some of her characters. After they broke up, she met Jean Toomer, author of the novel *Cane* and a central figure in the Harlem Renaissance. They went back to Wisconsin and married, despite anti-miscegenation laws—and prevailing attitudes. *Time* magazine published a story damning the union. Margery died after giving birth at age thirty-three.

The Way Your Blood Beats

Margery was close friends with **Georgia O'Keeffe**.
Not long after Margery's death, **Jean** went to
visit Georgia, and letters (this from Georgia:
"I like knowing the feel of your maleness
and your laugh—") suggest an affair.

From a few letters, it appears **Frida Kahlo** *had a crush on* **Georgia**. *Georgia wrote many letters throughout her life, but she never seemed to write Frida back.*

See page 5

Georgia O'Keeffe

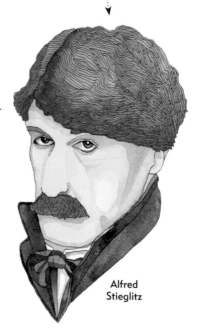

Alfred Stieglitz

Alfred Stieglitz was married when he met Georgia O'Keeffe, but she became his muse and soon his next wife. He introduced her to Paul Strand, another young artist, and Georgia and Paul began a passionate correspondence, Georgia once writing that she had to be naked when she composed her letters because he caused her to overheat. Years later, Alfred had an affair of his own with Paul's wife, Beck. Georgia then followed suit.

The painter **Beauford Delaney**,
largely unrecognized now, was admired by
many artists and thinkers of his time. He was a regular
in Alfred's gallery in New York. Georgia drew a few portraits
of him, one of only two people she was ever known to depict.
Adored by many, Beauford was tormented by mental illness
and a lifelong struggle to suppress his homosexuality.
He fled America for Paris in the '50s, never to return.

Henry Miller's article
*"The Amazing and Invariable
Beauford Delaney" amplified
Beauford's growing celebrity
in Greenwich Village.*

See page 13

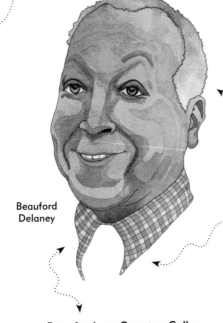

Beauford
Delaney

James Baldwin called Beauford "the first living proof,
for me, that a black man could be an artist" and
"a cross between Brer Rabbit and St. Francis of Assisi."
Beauford helped **James** find a way to pay for his
father's funeral when James was still a teenager. They
later traveled together in Europe. When Beauford died in
a mental hospital, James had a mental breakdown of his
own and he couldn't attend the funeral.

Beauford met **Countee Cullen**
when they were in their twenties, both
living in Boston. They would reconnect
during the Harlem Renaissance.

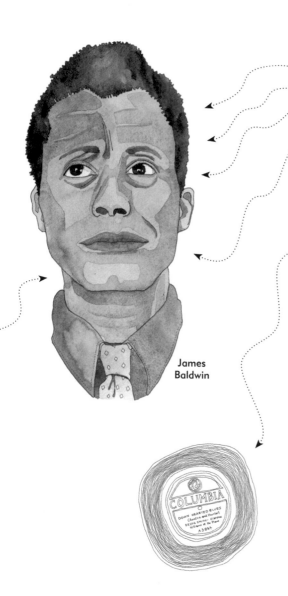

James Baldwin

James Baldwin met the man he would call the love of his life, Lucien Happersberger, a young painter, while in Paris in 1949. Lucien took James away to his family's home in Switzerland; the city was stressing him out. They spent three years there, Lucien painting and playing Bessie Smith records, and James completing *Go Tell It on the Mountain*. Lucien's former girlfriend, Suzy, eventually moved in and soon became pregnant, leaving James heartbroken. James moved back to New York alone; Lucien named his son Luc James. Two years later, Lucien left his wife and son to reunite with James, who reluctantly accepted Lucien's proposal to be non-monogamously together. James's next novel, *Giovanni's Room*, dedicated to Lucien, was from the point of view of a bisexual blonde man caught between the love of his fiancée and a male lover. When the couple split again, James headed to Paris for what he called "sad and aimless" years. In 1960, Lucien sent James a letter suggesting they try again. They were together, with occasional breaks, for the next few years, and Lucien acted as his business manager at the height of James's career. Though the relationship was on shaky ground, they moved back to France in 1970, and when James fell ill, Lucien took care of him. He was at his bedside when James died.

Langston got an unfavorable review in the *New York Times* from **James Baldwin** for his book of selected poems. First line: "Every time I read Langston Hughes I am amazed all over again by his genuine gifts— and depressed that he has done so little with them."

Langston Hughes

Zora Neale Hurston

Zora's *novel* Their Eyes Were Watching God *was critically torn apart by* **Richard Wright**, *who was good friends with* **Langston**.

See page 47

Langston Hughes and Zora Neale Hurston
were both part of a group of literary friends whose aim was to provide a counterpoint to the developing status quo of the Harlem Renaissance. Together with Wallace Thurman and others, they published a one-issue literary magazine, *Fire!!*, so named, Langston said, because their aim was "to burn down everything old." Langston and Zora later collaborated on a play called *Mule Bone*, setting out to write a comedy starring African Americans that wouldn't rely on stereotypes. Though friends when they began writing, they had a complete falling out by the end, and Zora submitted the play for copyright and production without his name.

65

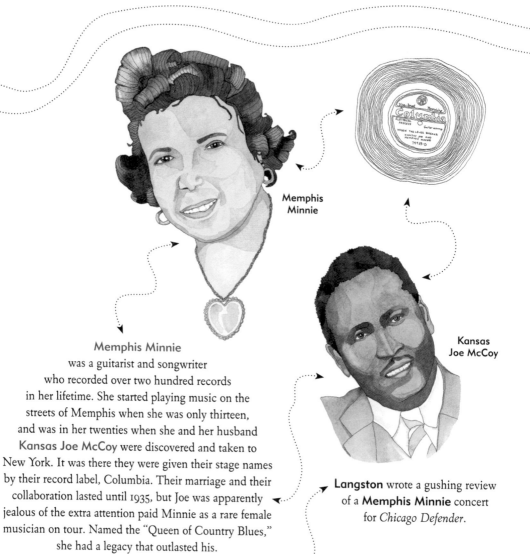

Memphis
Minnie

Kansas
Joe McCoy

Memphis Minnie
was a guitarist and songwriter
who recorded over two hundred records
in her lifetime. She started playing music on the
streets of Memphis when she was only thirteen,
and was in her twenties when she and her husband
Kansas Joe McCoy were discovered and taken to
New York. It was there they were given their stage names
by their record label, Columbia. Their marriage and their
collaboration lasted until 1935, but Joe was apparently
jealous of the extra attention paid Minnie as a rare female
musician on tour. Named the "Queen of Country Blues,"
she had a legacy that outlasted his.

Langston wrote a gushing review
of a **Memphis Minnie** concert
for *Chicago Defender*.

Countee Cullen

Canada Lee starred in **Orson Welles**'s all-black production of *Macbeth*, which one of **James Baldwin**'s teachers took him to see. It had a lasting impact. Canada also played Bigger Thomas in the stage version of **Richard Wright**'s *Native Son* in New York in 1941, also under Orson Welles's direction.

Canada's longtime lover, **Caresse Crosby**, brought her friend **Anaïs Nin** to see the production.

Countee Cullen was James Baldwin's French teacher at DeWitt Clinton High School. There James ran a literary magazine with Richard Avedon. Countee was already close with **Beauford Delaney**, who would become one of James's greatest mentors.

Canada Lee

In his twenties, **Countee Cullen** came in second to his friend **Langston Hughes** in a poetry contest. Countee married Yolande Du Bois, the daughter of W. E. B., but like Langston and several other artists of color in the Harlem Renaissance, he was said to be living in the closet, and they divorced after two years.

Though they were both married when they met, the filmmaker Orson Welles and the actress Dolores del Río started an affair that ended both their marriages. They were together for a few years, through the filming and premiere of *Citizen Kane*, considered Orson's greatest work. Dolores broke things off in 1941, and shortly thereafter he married Rita Hayworth, an actress who was being touted as "the new Dolores del Río." Rita and Orson's daughter, Rebecca, later said her father was obsessed with Dolores for the rest of his life. Rebecca was intrigued enough that she traveled to Mexico for her eighteenth birthday to meet Dolores herself.

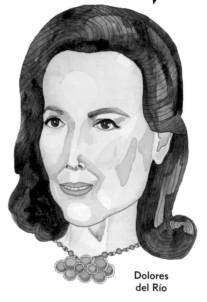

Dolores was friends with **Frida Kahlo** *and* **Diego Rivera**.

See page 5

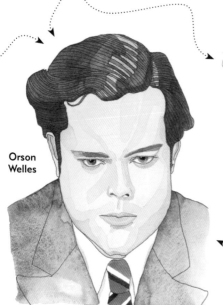

Orson
Welles

Rita
Hayworth

Dolores
del Río

Orson also had an affair with Billie Holiday, whom he wanted to cast as Bessie Smith in a film he was hoping to make about **Louis Armstrong**'s life. The film was never made, but was later reinvented as the film *New Orleans*, with a role for Billie.

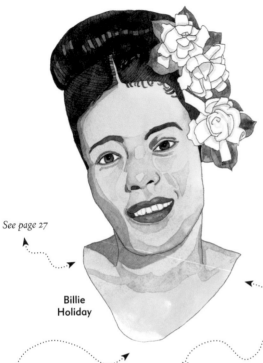

See page 27

**Billie
Holiday**

Tennessee Williams first met **Tallulah**
backstage before a play, where she was putting
on makeup while completely naked. He'd written
a part for her, but she dismissed his new play
as "degenerate filth." She later performed in a
production of *A Streetcar Named Desire*,
but Tennessee criticized her work in an open
letter to the *New York Times*, calling it
"the worst performance ever
of Blanche DuBois."

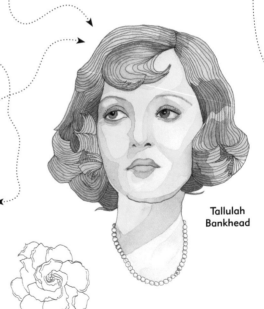

**Tallulah
Bankhead**

In the late '40s, Tallulah
Bankhead, an actress outspoken about
her affairs with both men and women, stopped
by the Strand to see her lover, Billie Holiday.
An exhibitionist, Tallulah insisted on keeping the
dressing room door open, scandalizing everyone
backstage. Though they later had a falling out,
Tallulah once wrote a letter to FBI director
J. Edgar Hoover in an attempt to exonerate
Billie of the drug charges that had been
following her around for years.

See page 43

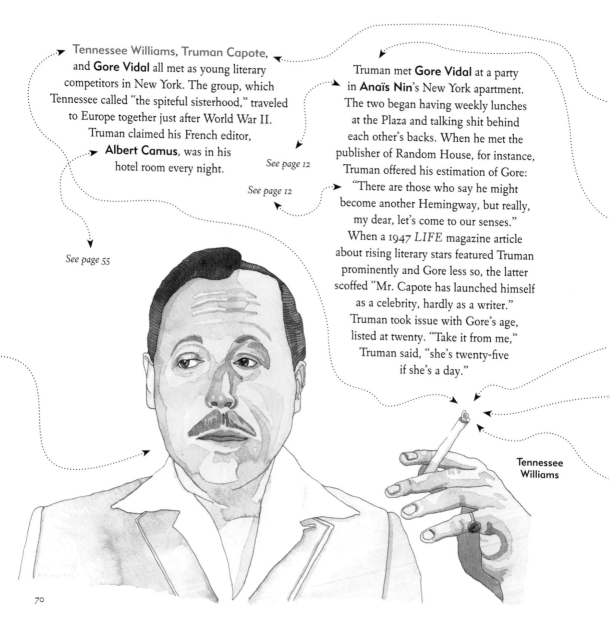

Tennessee Williams, Truman Capote, and **Gore Vidal** all met as young literary competitors in New York. The group, which Tennessee called "the spiteful sisterhood," traveled to Europe together just after World War II. Truman claimed his French editor, **Albert Camus**, was in his hotel room every night.

See page 12

See page 12

See page 55

Truman met **Gore Vidal** at a party in **Anaïs Nin**'s New York apartment. The two began having weekly lunches at the Plaza and talking shit behind each other's backs. When he met the publisher of Random House, for instance, Truman offered his estimation of Gore: "There are those who say he might become another Hemingway, but really, my dear, let's come to our senses." When a 1947 *LIFE* magazine article about rising literary stars featured Truman prominently and Gore less so, the latter scoffed "Mr. Capote has launched himself as a celebrity, hardly as a writer." Truman took issue with Gore's age, listed at twenty. "Take it from me," Truman said, "she's twenty-five if she's a day."

Tennessee Williams

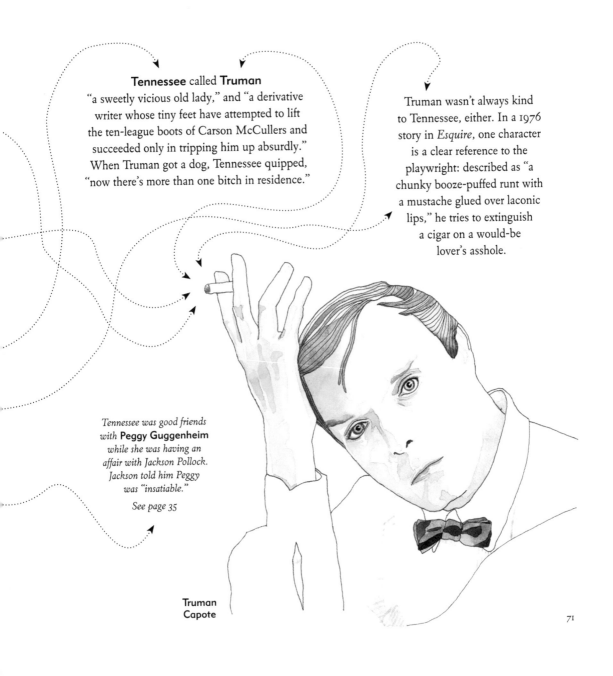

Tennessee called **Truman** "a sweetly vicious old lady," and "a derivative writer whose tiny feet have attempted to lift the ten-league boots of Carson McCullers and succeeded only in tripping him up absurdly." When Truman got a dog, Tennessee quipped, "now there's more than one bitch in residence."

Truman wasn't always kind to Tennessee, either. In a 1976 story in *Esquire*, one character is a clear reference to the playwright: described as "a chunky booze-puffed runt with a mustache glued over laconic lips," he tries to extinguish a cigar on a would-be lover's asshole.

Tennessee was good friends with **Peggy Guggenheim** *while she was having an affair with Jackson Pollock. Jackson told him Peggy was "insatiable."*

See page 35

Truman Capote

71

The Smiths

 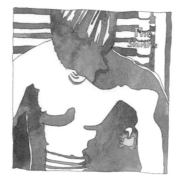 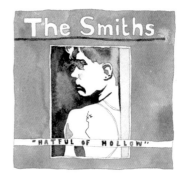

"This Charming Man"
The Smiths

The Smiths
The Smiths

Hatful of Hollow
The Smiths

*The single of **"This Charming Man"**
features a still of the very charming
Jean Marais in the film Orphée,
directed by his longtime lover,
Jean Cocteau.*

***The Smiths** self-titled album cover
is a still of **Joe Dallesandro**
in the **Andy Warhol**
film Flesh.*

*The original art for **Hatful of Hollow**
is a photograph of a young man tattooed
with a drawing by **Jean Cocteau**,
though subsequent covers crop
out his tattooed shoulder.*

The Smiths

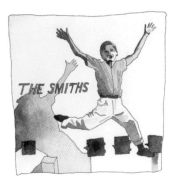

"The Boy with a Thorn in His Side"
The Smiths

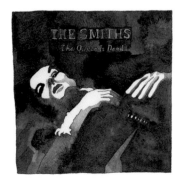

The Queen Is Dead
The Smiths

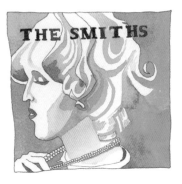

"Sheila Take a Bow"
The Smiths

A photograph of a young **Truman Capote** *jumping is on the cover of* **"The Boy with a Thorn in His Side"** *single. Morrissey dispelled rumors that the song was about* **Oscar Wilde**, *but the title could also easily refer to Truman's thorny streak.*

The Queen Is Dead cover is a photo of **Alain Delon**, *ex-partner and baby-daddy of* **Nico**, *from the film* L'Insoumis.

The cover to the **"Sheila Take a Bow"** *single is a still of* **Candy Darling** *from the* **Andy Warhol** *film* Women in Revolt.

Chelsea Girls

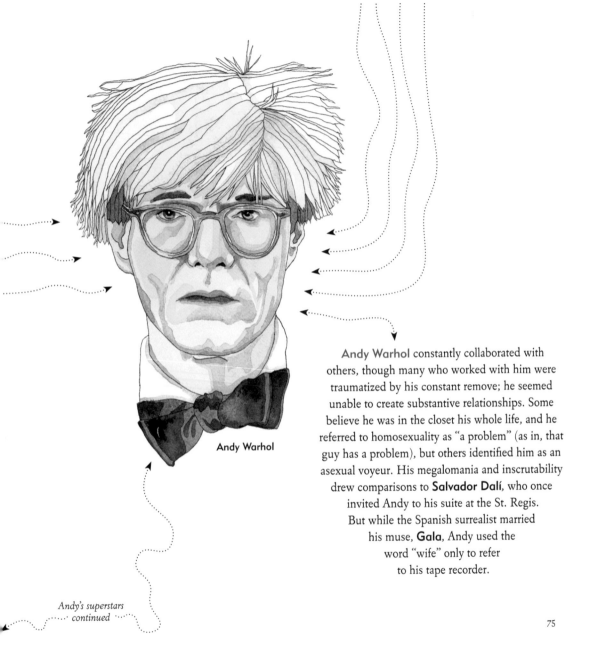

Andy Warhol

Andy Warhol constantly collaborated with others, though many who worked with him were traumatized by his constant remove; he seemed unable to create substantive relationships. Some believe he was in the closet his whole life, and he referred to homosexuality as "a problem" (as in, that guy has a problem), but others identified him as an asexual voyeur. His megalomania and inscrutability drew comparisons to **Salvador Dalí**, who once invited Andy to his suite at the St. Regis. But while the Spanish surrealist married his muse, **Gala**, Andy used the word "wife" only to refer to his tape recorder.

Andy's superstars continued

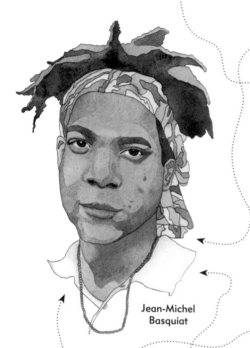

Jean-Michel
Basquiat

When an art dealer brought **Jean-Michel Basquiat** to meet **Andy Warhol** at the Factory in 1982, Andy immediately took a Polaroid and soon presented Jean-Michel with a large screen print of his face. Jean-Michel rushed back to his studio, created a portrait of himself and Andy side by side, and had it sent back up to the Factory, the paint still wet. They soon began to collaborate on a series of paintings and painted punching bags. Jean-Michel's influence led Andy to return to painting on canvas, which he had mostly given up since the '60s. Andy's influence was said to decrease Jean-Michel's drug use, but after Andy's unexpected death in 1987, Jean-Michel was sent over the edge, dying of a heroin overdose the next year.

Madonna and **Jean-Michel** had a brief relationship in 1982, though he had a girlfriend at the time. The girlfriend, Suzanne Mallouk, found out and violently confronted Madonna at a club, inspiring Jean-Michel's painting *Catfight*, which featured Madonna's name crossed out. When the two split for good, Jean-Michel made Madonna return the paintings he'd given her, painting them solid black.

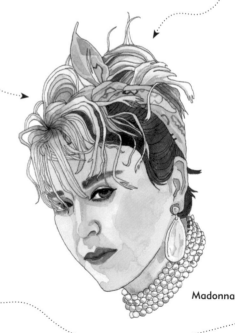

Madonna

Madonna and Keith Haring both worked at the Danceteria in the early '80s, he as a busboy and she as a coat-check girl. (Sade, LL Cool J, and the Beastie Boys also worked there around the same time.) Keith and Madonna were close and, in the years before her music career took off, she often slept on his couch, unable to afford an apartment of her own. When she performed at Keith's twenty-sixth birthday party, his mentor and friend **Andy Warhol** was in attendance. When she married Sean Penn in 1985, Keith brought Andy as his date.

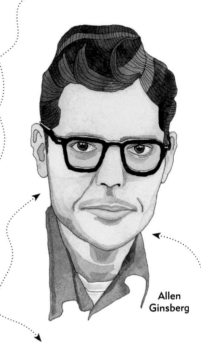

Allen
Ginsberg

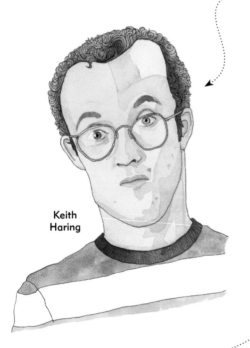

Keith
Haring

The poet Allen Ginsberg, a central figure in the Beat Generation, remained at the center of the art world throughout his life. He played himself in a Warhol film alongside Edie Sedgwick. He wrote a poem for **Frank O'Hara** called "My Sad Self." He even hung out with Jean-Michel Basquiat toward the end of the artist's life, giving him an annotated copy of his famous poem *Howl*.

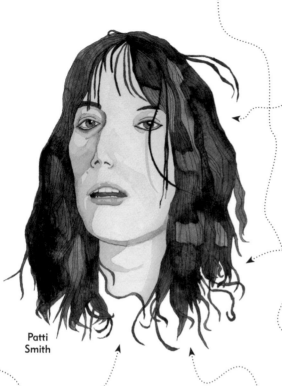

Patti
Smith

Patti Smith and **Robert Mapplethorpe** lived together in Brooklyn and later the Chelsea Hotel while the two were in their twenties. Robert told his conservative parents he had married Patti in a strawberry field in California so they would accept the living situation. In her memoir *Just Kids*, Patti calls him the "artist of my life," and after they parted ways as lovers, they still made art together. Robert took the cover portrait for her breakout album, *Horses*.

When the pair met **Andy Warhol**, he dismissed them as "horrible" and "dirty." Robert looked up to Andy, but Patti didn't understand the appeal. "I felt little for the can and didn't like the soup," she said, though many years later she grew to appreciate his work.

While trying to buy a sandwich at a diner in the East Village, Patti came up a dime short. **Allen Ginsberg** happened to overhear and covered the difference, mistaking her for an attractive boy. They became friends anyway.

Robert Mapplethorpe said his desire to meet **Andy Warhol** was part of the reason he moved to New York. After they did meet, Robert realized that Andy wasn't the type to mentor other artists, later saying, "People helped Warhol— not the other way around."

Patti met **Sam Shepard** at a nightclub where he was playing drums in a band. At twenty-six, he was already a six-time Obie-winning playwright, but he initially kept his career a secret from her. Also a secret was his wife and newborn son, but Patti stayed with him after she found out.

Sam and **Patti** co-wrote the play *Cowboy Mouth* and co-starred as aspiring rock musicians who fall in love after one kidnaps the other. Though Sam was always successful as a playwright, recognition as a rock star eluded him.

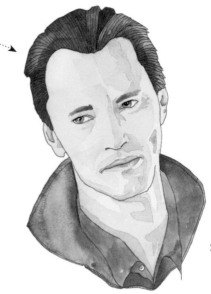

Sam
Shepard

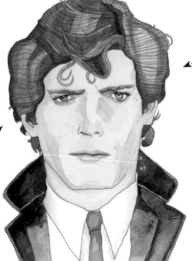

Robert's photography career took off sharply in the years before his death, with his controversial but acclaimed photographs earning him a retrospective at the Whitney Museum in 1988. He died of AIDS the following year at forty-two.

Robert
Mapplethorpe

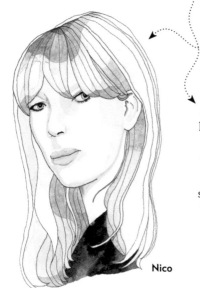

Nico

Christa Päffgen, better known as Nico, broke her modeling contract with **Coco Chanel** to pursue a career as an actress in New York. There she quickly fell in with **Andy Warhol**'s crowd. She was cast in the film *Chelsea Girls* and a handful of others, though she's better remembered as a singer for the Velvet Underground, which Andy was managing at the time. She was brought in at Andy's insistence and was only a part of the band for a single album. Though **Lou Reed** wrote a few songs for her to sing, he disliked working with her. Nico claimed this was because of "what her people had done to his people," referring to her German and his Jewish heritage. After an affair with the French actor Alain Delon, she had a son that he refused to claim—though it was Alain's mother who ultimately raised the child. Alain was also a Smiths album cover boy.

See page 73

Alain
Delon

Candy Darling, an actress and model, became one of Warhol's superstars, starting with a role in *Flesh* alongside **Joe Dallesandro**. The two were later photographed together by Richard Avedon. She also had a leading role in Warhol's *Women in Revolt* and became a close friend of **Lou Reed** and muse to the Velvet Underground. A transgender icon ahead of her time, she died at twenty-nine of lymphoma. Candy is the cover girl for the Smiths single **"Sheila Take a Bow."**

See page 73

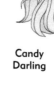

Candy
Darling

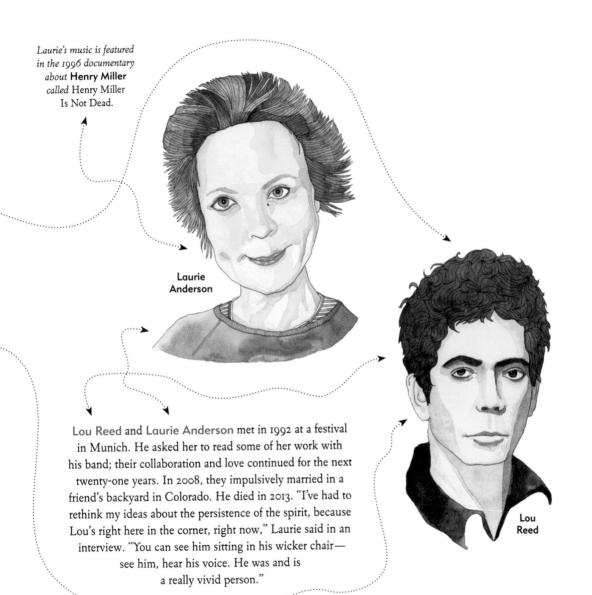

Laurie's music is featured in the 1996 documentary about **Henry Miller** called Henry Miller Is Not Dead.

Laurie
Anderson

Lou
Reed

Lou Reed and Laurie Anderson met in 1992 at a festival in Munich. He asked her to read some of her work with his band; their collaboration and love continued for the next twenty-one years. In 2008, they impulsively married in a friend's backyard in Colorado. He died in 2013. "I've had to rethink my ideas about the persistence of the spirit, because Lou's right here in the corner, right now," Laurie said in an interview. "You can see him sitting in his wicker chair—see him, hear his voice. He was and is a really vivid person."

The Ends

Edith Piaf's health had been failing in serious ways for several months before she died in 1963. When her very close friend **Jean Cocteau** heard that she had passed, he promptly had a heart attack and died the same day.

Larry Rivers spoke angrily at the burial of his friend and lover **Frank O'Hara**. "He died horribly in an absurd situation, in the soft, safe sand of Long Island." Though some accounts of the accident conflict, most agree that Frank was struck by a jeep driving on the beach at Fire Island early one July morning in 1966. He was forty.

When **Isadora Duncan** got into an Amilcar automobile on a beautiful September night in 1927, she was reported to have said "Farewell my friends! I am off to love," the implication being that she was having an affair with the young driver. During the journey, however, her silk scarf, extravagantly long and blood red to denote her allegiance to the communist party, became tangled in the back wheel, pulling her from the car and snapping her neck. She died on the scene. **Gertrude Stein** only had this to say: "Affectations can be dangerous."

The Ends

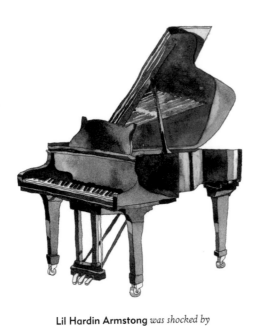

Lil Hardin Armstong *was shocked by*
Louis Armstrong's *sudden death by heart attack.*
Though they had been divorced for decades, she
rode in the family car of the funeral procession.
Ella Fitzgerald *and Frank Sinatra were*
honorary pallbearers, and Peggy Lee
sang the Lord's Prayer. A month later,
during a televised memorial concert,
Lil collapsed at the piano while
playing "St. Louis Blues" and
died shortly thereafter.

In 1925, **Frida Kahlo** *was riding a bus*
when it was hit by a streetcar, and she was impaled
by a handrail. In a painting of her last memory before
the collision, she is wearing a red scarf similar to the
one that Isadora wore when she died. The painful
complications in the decades following the accident
were intense, and though there was no autopsy,
her eventual death was thought to have been suicide,
possibly to escape the pain. Days before she died,
she wrote in her journal, "I hope the exit is joyful—
And I hope to never return—Frida."
A distraught **Diego Rivera** *is said by witnesses*
to have eaten a handful of her ashes.

A NOTE ON SOURCES

A great many obituaries, articles, and biographies were consulted
to find and check facts. A few books, however, stood out as not
just good resources, but clear windows into the ways that the
relationships depicted here informed these artists' works.

Outlaw Marriages by Rodger Streitmatter was a gorgeous and
often heartbreaking collection of the queer marriages that existed
long before the Supreme Court recognized them. The chapter on James
Baldwin and Lucien Happersberger was especially gripping, as was the
saga of Greta Garbo and Mercedes de Acosta. *Two Lives: Gertrude and
Alice* by the incredible Janet Malcolm was my favorite resource on that
famous pair. *The Lives of the Muses* by Francine Prose is a work
of art in itself. The haunting, brief life of Harry Crosby was
beautifully depicted in Geoffrey Wolff's *Black Sun*.

Justin Spring's biography of Samuel Steward, *Secret Historian*,
was a great discovery and shocking in the best ways. Cassandra
Langer's biography on Romaine Brooks and David Leeming's work
on Beauford Delaney made me wonder what other great painters are
underappreciated. *A Chance Meeting* by Rachel Cohen was an early
find and a favorite; each chapter depicts a different brief meeting or
friendship, often between disparate artists. I laughed most of the time
I read *The Pink Triangle* by Darwin Porter and Danforth Prince—
highbrow gossip at its height.

ACKNOWLEDGMENTS

We feel very fortunate to have worked with some incredible people to make this book happen. Our fearless designer, Andrew Shurtz, is a talent and a joy. Jessica Friedman, Jin Auh, and everyone the Wylie Agency had our backs, as did the folks at Bloomsbury: Rachel Mannheimer, Laura Phillips, Patti Ratchford, Callie Garnett, and the rest of the team. Thanks also to Peter Musante and Paul Stephens, who tolerated long meetings in their living rooms, and to the many friends who suggested stories to include.

A hat tip is owed to Graham Greene for writing *The End of the Affair*, which inspired both the title and the idea. Catherine is also grateful to the folks at *The Believer*, who ran an earlier iteration of this idea in their fine magazine some years ago.

A NOTE ON THE
AUTHOR AND ILLUSTRATOR

Catherine Lacey is
the author of the novels
Nobody Is Ever Missing
and *The Answers*. She
is based in Chicago.

Forsyth Harmon is
a writer and illustrator
based in New York.
She is completing
her first novel.